Painting Loose Landscapes in Watercolour

by

Steven Cronin

Other titles by Steven Cronin

Watercolour Painting Made Simple
Watercolour Painting Made Simple Vol.2
Watercolour Painting Made Simple Vol.3
Watercolour Painting Made Simple Vol.4
Watercolour Landscapes: Reference Paintings
For Students

All titles available at
amazon.com/author/stevencronin

CONTENTS

Introduction

Many moons ago I thought I would try my hand at watercolour painting. Since I was a child I had enjoyed watching artists at work but never thought I had the patience to try myself. I always thought painting was about realism, every leaf and blade of grass had to be meticulously brushed in, every texture and shadow painstakingly applied in a way only the most patient of saints were capable of. Then one day I discovered another way of painting, a fast and loose style that immediately drew me in. Suddenly I realised there was a gateway so I bought the basic kit and gave it a go.

In 'Painting Loose Landscapes in Watercolour' I'll show you the free and easy style and techniques I've tried to evolve since that first day I picked up a hake brush and with a little patience there is absolutely no reason why anybody cannot do the same. Painting loosely allows the individual to really go to town and place their signature on

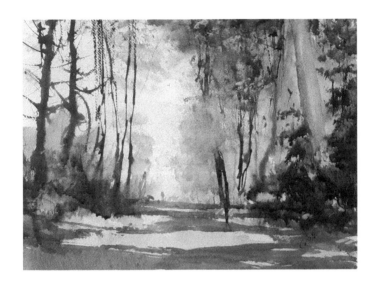

the watercolour. It certainly helped inspire me in those early days.

One of the most important lessons I've learned is to not be afraid of making mistakes. We learn more from our mistakes than when things go right. There is never a wasted painting, we always learn something to take to the next composition. Above all, enjoy it and have fun. There is no right or wrong. Best of luck and happy painting.

Materials

From the very beginning I decided to keep my materials to the bare minimum and as simple as possible. I think this approach has allowed me to get intimate with my materials and learn exactly what they can and cannot do. I believe that progress comes through experimentation and confidence, not being afraid of making mistakes and learning through plenty of practise rather than more elaborate and expensive gear. For this reason I've

never really felt the need to expand my range of brushes or colours.

My main brush is the large Ron Ranson hake. This was the brush that really inspired me and set me off on my watercolour journey. My other main brush is a number three rigger. I recently added a size zero rigger for the finer points. I do occasionally use a ¾" flat and more recently a narrower ¼" flat for experimenting with shadows and the like.

I've used the same seven colours pretty much since I started: raw sienna, burnt umber, light red, ultramarine blue, lemon yellow, Payne's gray and alizarin crimson. With regards to paper, for beginners I would recommend something around 140 lb in weight. This will be thick enough to stop the paper buckling when wet but not too expensive. If you start off with expensive paper it will prevent you from experimenting as you'll be afraid of making mistakes and wasting your valuable paper. You will feel inhibited and unable to paint loosely which is what this technique is all about. Try to stick out each painting but if things go badly wrong then you can always turn the paper over and start again on the other side. For more details on my materials visit my YouTube channel at youtube.com/c/StevenCronin

'Late Afternoon' Step-By-Step Tutorial

Light and shadow play such an important part of landscape painting. Often, all we need is a narrow slither of light to bring the scene to life. I brushed much of the lower third in shadow and allowed the light to hit parts of the middle ground. The buildings are painted dark to contrast against the faint background hills and lower part of the sky. Don't be afraid to brush the clouds in dark. They will always dry lighter than you think so get them in strong first time. The darker the clouds, the brighter the light from the central region of sky.

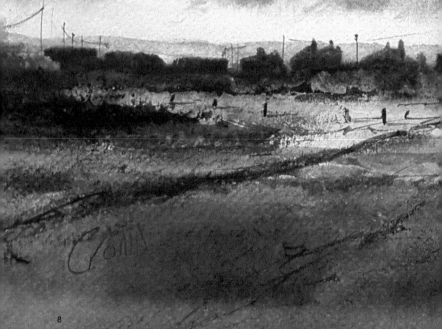

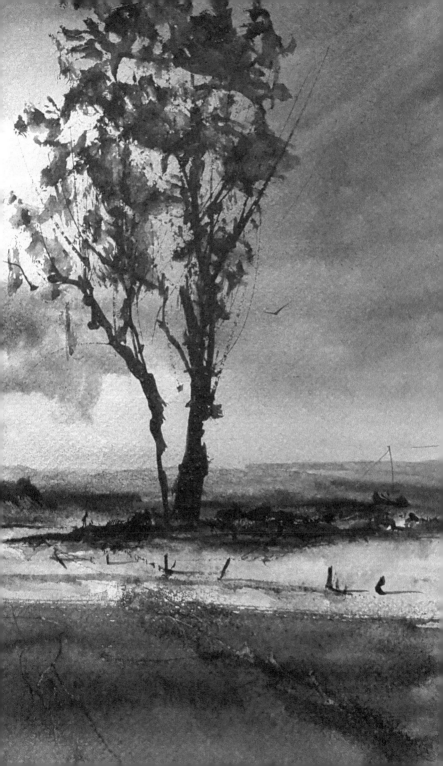

1. Begin the sky with an ultramarine / Payne's gray mix

2. Add some alizarin crimson while being careful to preserve the light region in the centre of the sky.

3. Mix the three colours together and brush in the clouds.

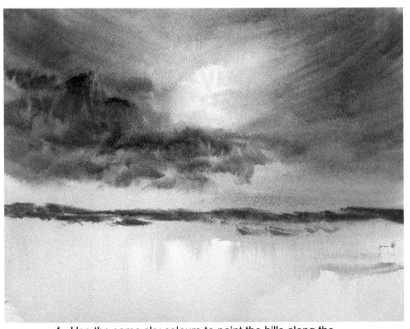

4. Use the same sky colours to paint the hills along the horizon.

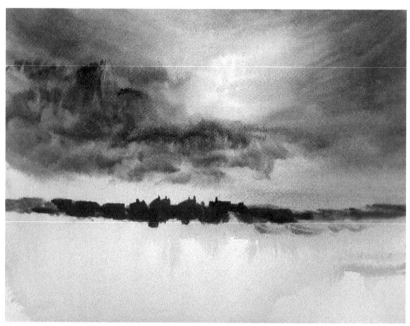

5. Use the flat brush to add the profiles of the buildings.

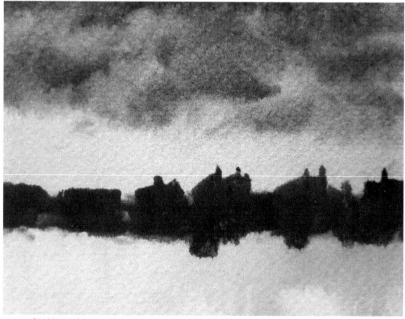

6. Use plenty of Payne's gray with the sky colours so the houses silhouette nicely against the lower sky.

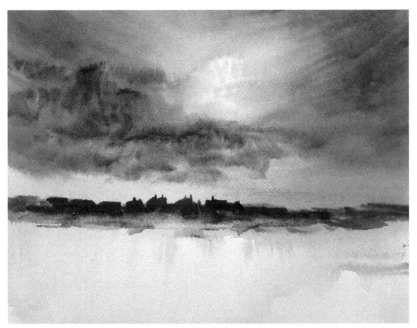

7. I brushed in some more buildings in raw sienna / light red using the flat brush.

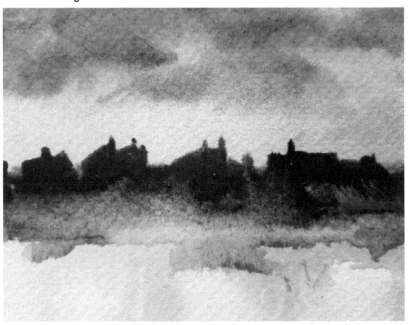

8. Use some lemon yellow to add grassy areas in front of the houses.

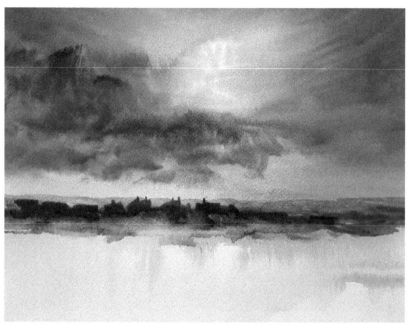

9. Use a light wash of the sky colours to add the distant hills.
This creates instant depth to the painting.

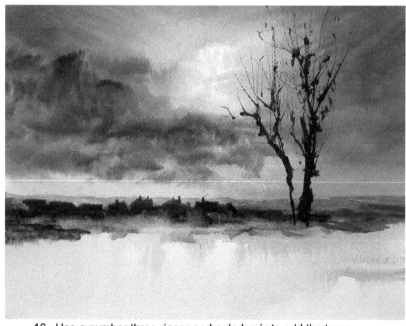

10. Use a number three rigger and a dark mix to add the trees.

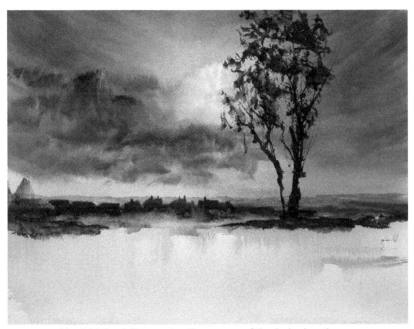

11. Add the foliage using the corner of the hake brush.

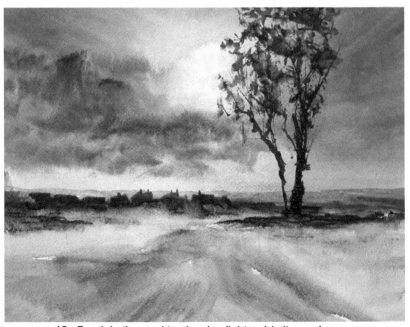

12. Brush in the road track using light red / ultramarine.

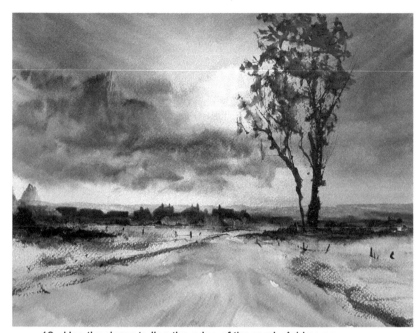

13. Use the rigger to line the edge of the road. Add some posts and random marks.

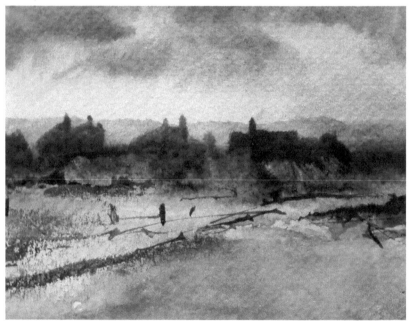

14. Add the rigger marks as loosely as you dare.

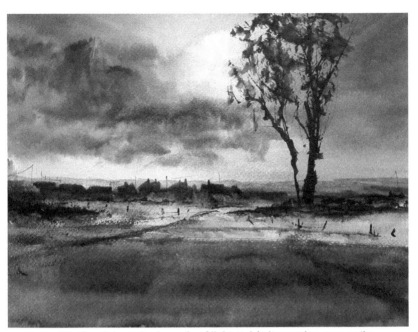

15. Brush in a shadow mix of light red / ultramarine across the foreground.

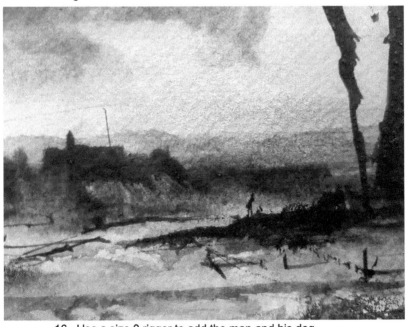

16. Use a size 0 rigger to add the man and his dog.

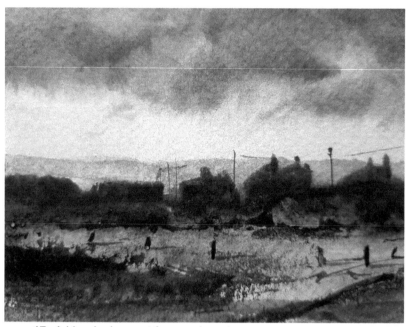

17. Add a shadow cast from each post.

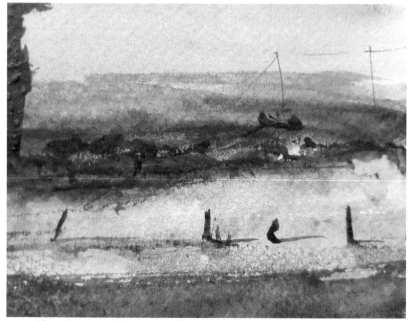

18. Add some faint telegraph poles.

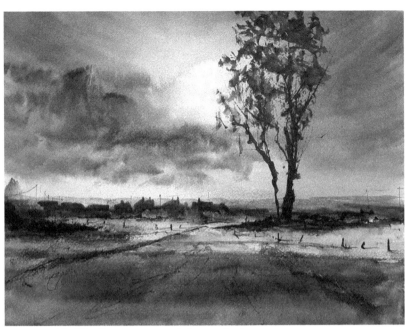

19. Finally, sign your painting and relax.

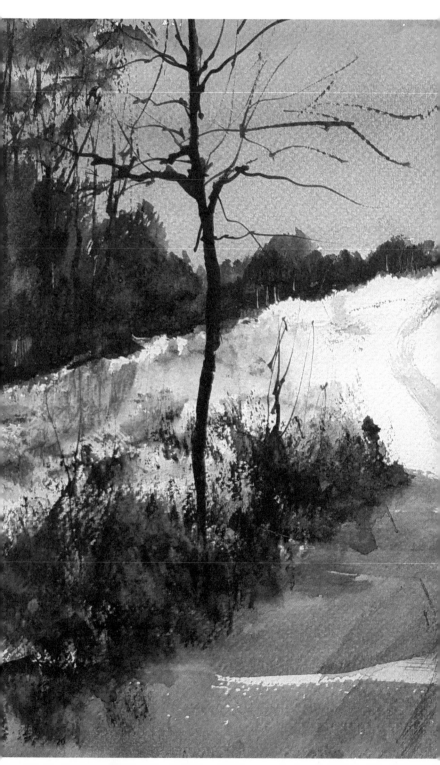

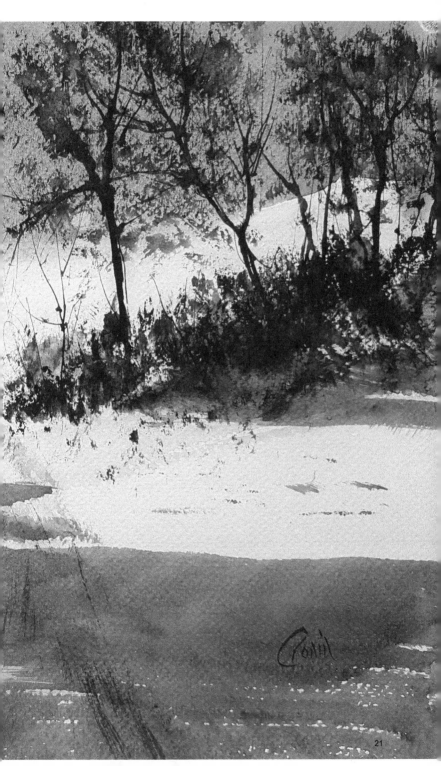

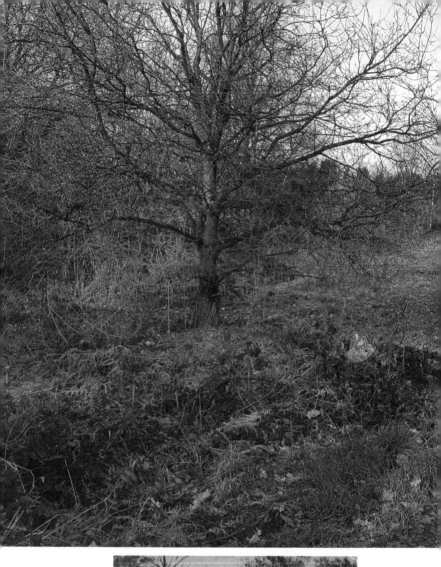

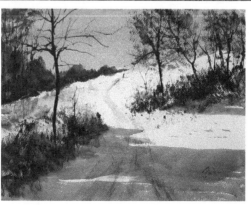

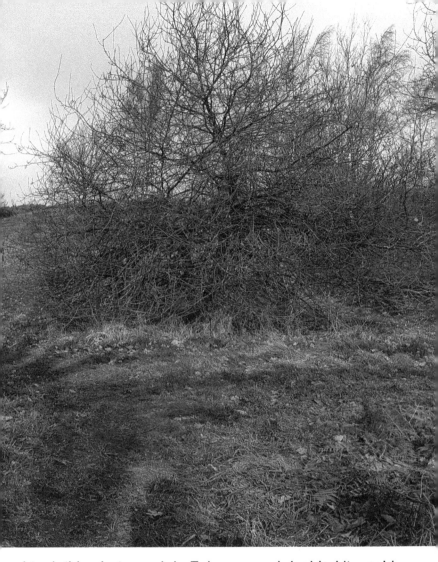

I took this photograph in February and decided it would look better with snow. A limited palette of raw sienna, burnt umber and ultramarine offers of characteristic winter look. I lowered the left side tree for a more pleasing composition.

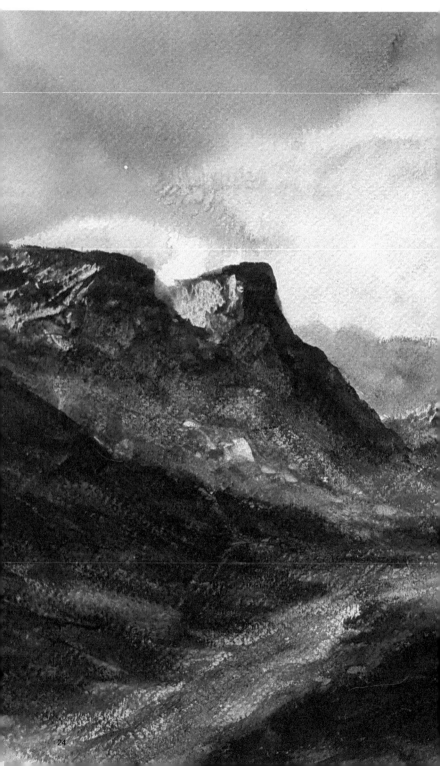

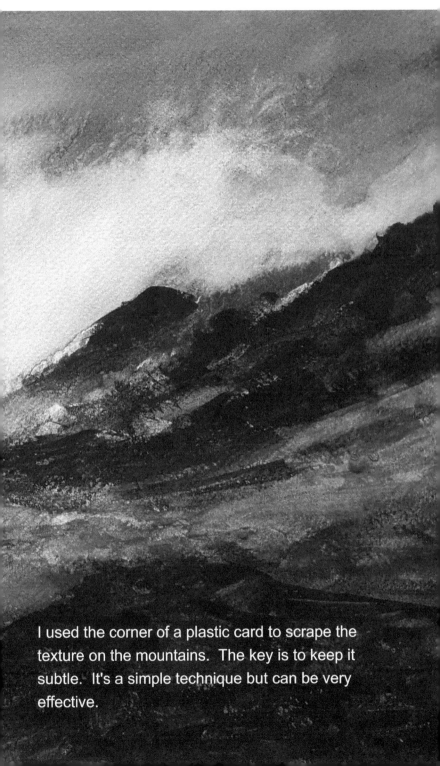

I used the corner of a plastic card to scrape the texture on the mountains. The key is to keep it subtle. It's a simple technique but can be very effective.

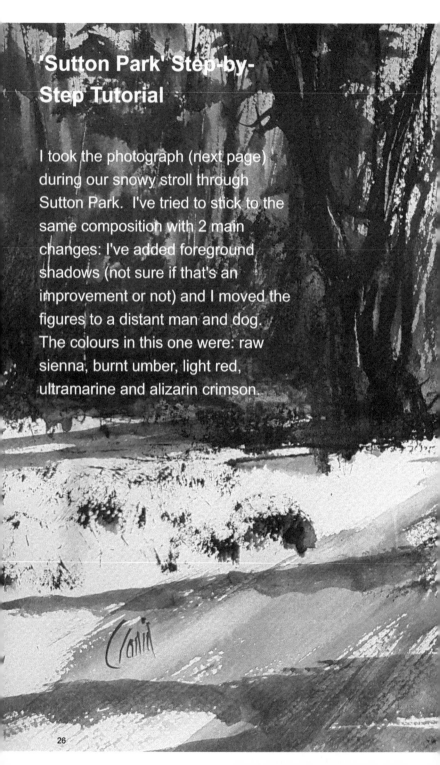

'Sutton Park' Step-by-Step Tutorial

I took the photograph (next page) during our snowy stroll through Sutton Park. I've tried to stick to the same composition with 2 main changes: I've added foreground shadows (not sure if that's an improvement or not) and I moved the figures to a distant man and dog. The colours in this one were: raw sienna, burnt umber, light red, ultramarine and alizarin crimson.

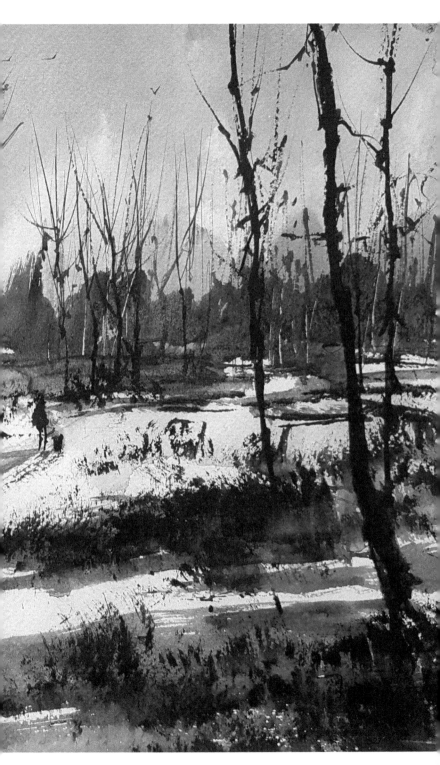

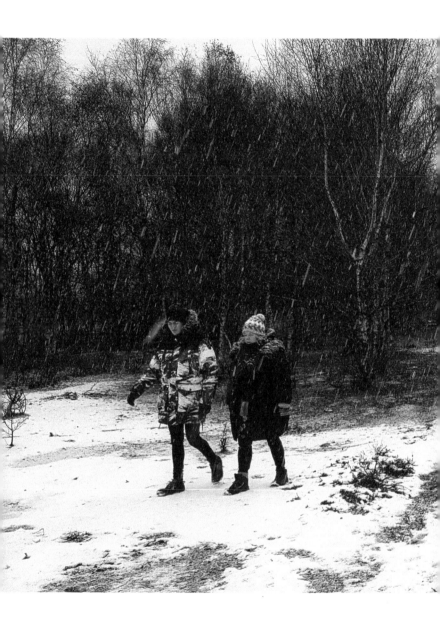

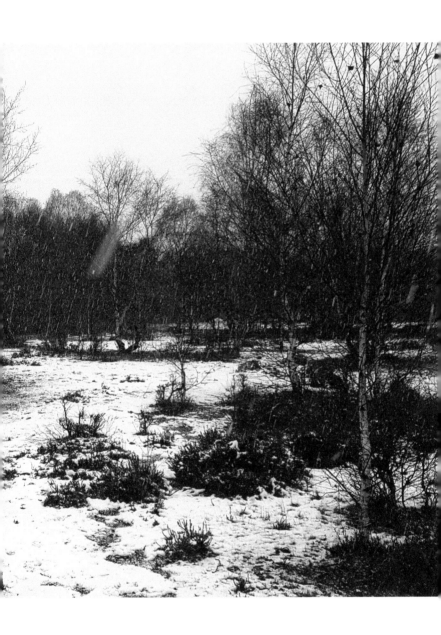

1. I began the sky with a loose mix of ultramarine, alizarin crimson and raw sienna.

2. I used a clean tissue to to soak up some of the wash.

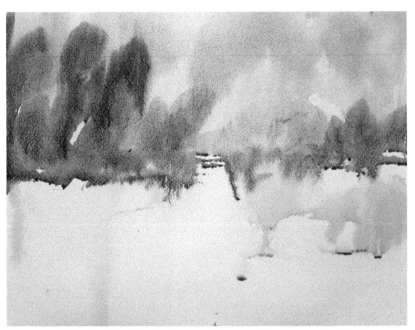

3. Start adding the background trees and bushes using the sky colours plus a touch of light red and burnt umber.

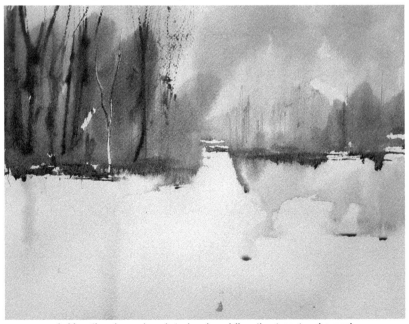

4. Use the rigger brush to begin adding the tree trunks and branches.

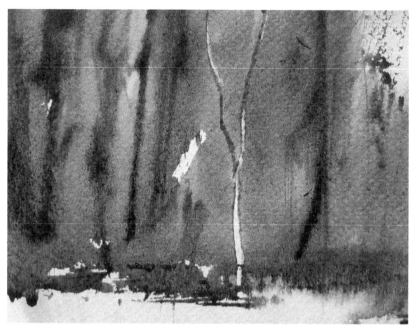

5. Use your fingernail to scrape in additional tree trunks.

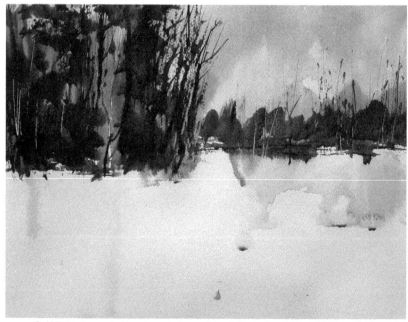

6. When the paint is almost dry, add additional washes to
darken the tonal values.

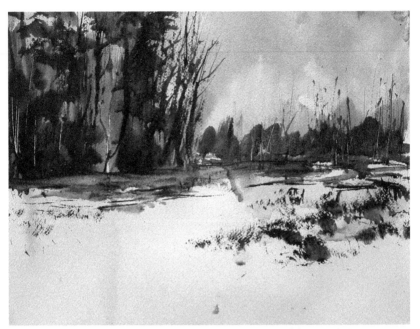

7. Use the hake to start adding the middle and foreground details.

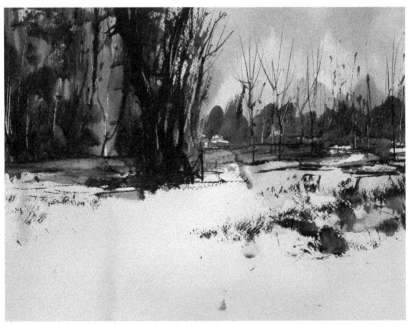

8. Use the rigger to brush in the closer trees.

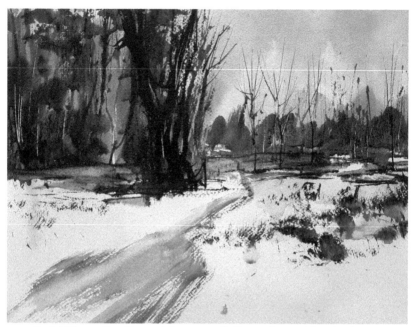

9. Add the path with a quick sweep of ultramarine and touch of light red.

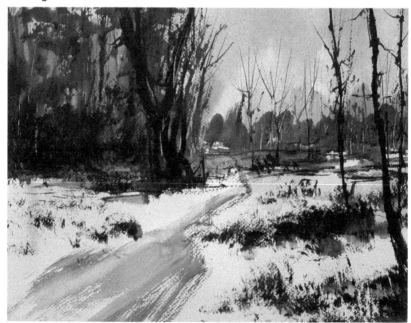

10. Add the foreground tree trunks with the rigger brush.

11. Leave plenty of untouched white to represent the snow.

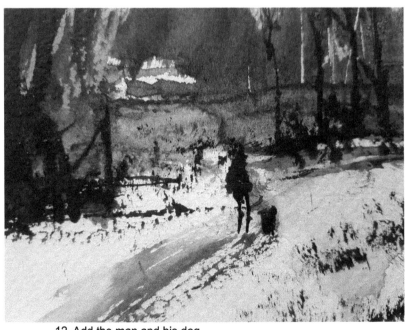

12. Add the man and his dog.

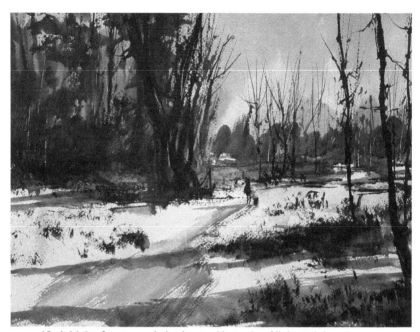

13. Add the foreground shadows with a mix of light red, burnt umber and ultramarine.

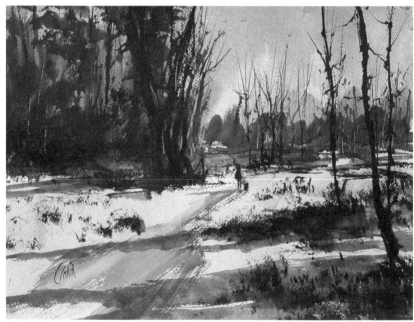

14. Finally sign your painting and frame.

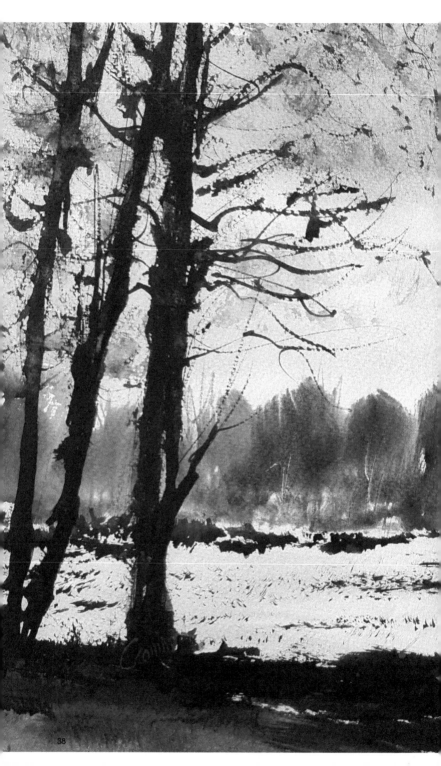

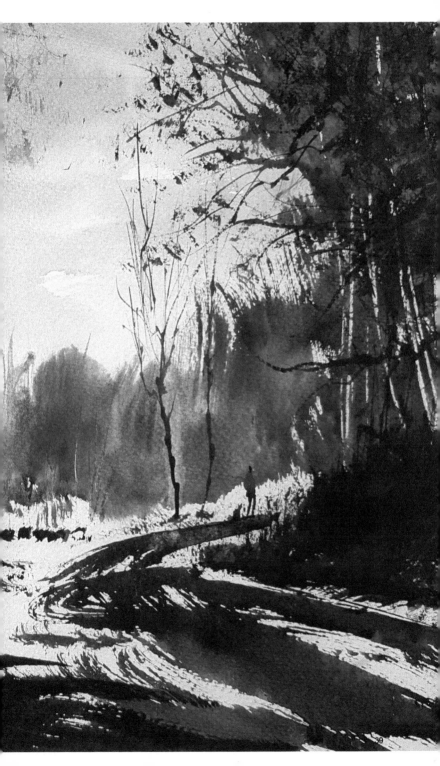

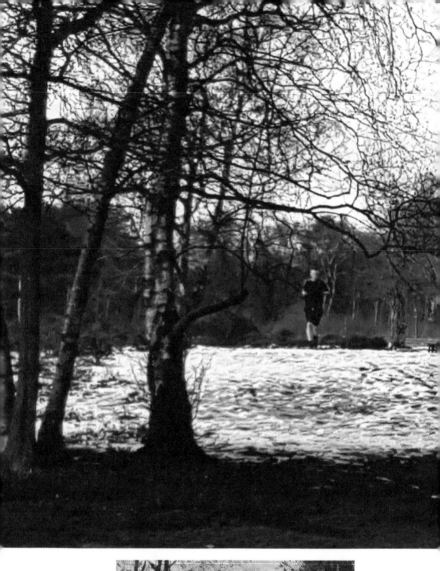

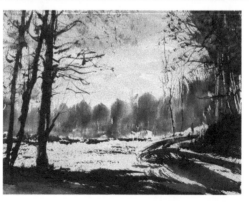

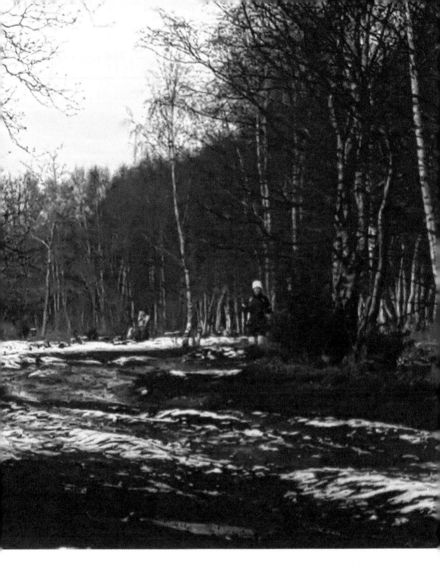

There wasn't too much thinking required with this reference photograph as the tones were already there or thereabouts and contrasting nicely with the snow. The better the reference the easier the painting becomes.

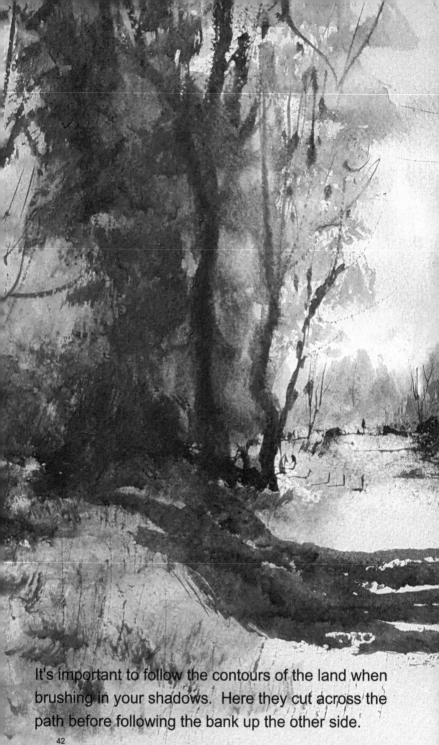

It's important to follow the contours of the land when brushing in your shadows. Here they cut across the path before following the bank up the other side.

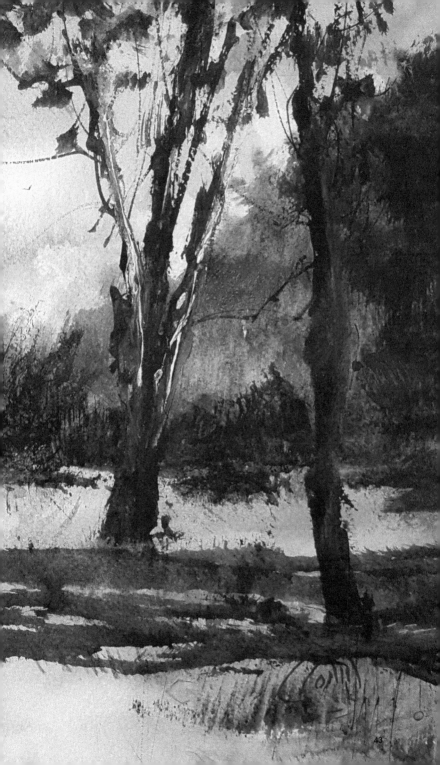

'Yorkshire Moors' Step-by-Step Tutorial

Here I've deliberately kept the horizon light so the buildings and foreground tree would silhouette and contrast well. Sometimes it may take two or three washes to get the desired dark tone. Just remember to dry in between to build up the layers.

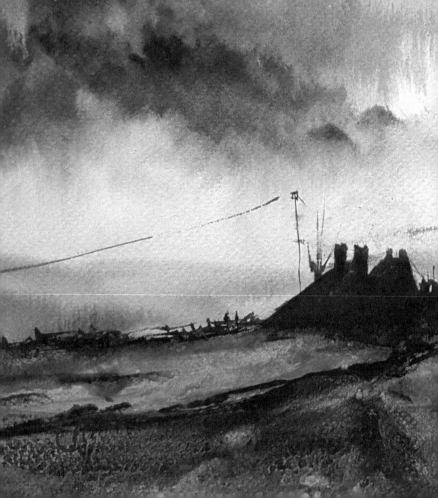

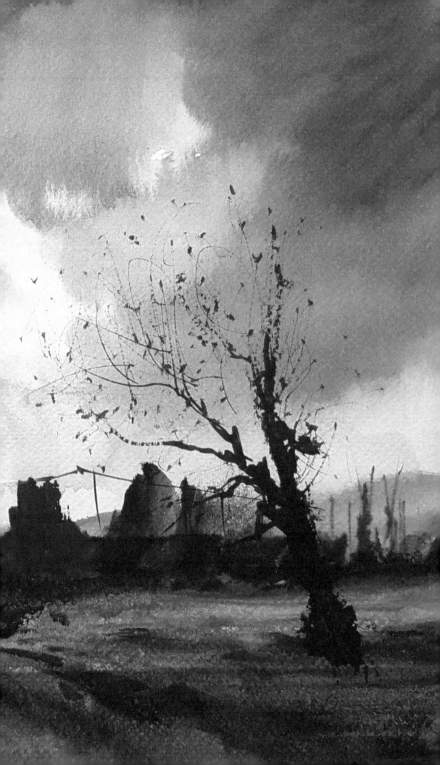

1. Brush in the sky using ultramarine / alizarin crimson /
Payne's gray leaving a gap in the middle to suggest the light.

2. Use a clean, dry brush to soften the bottom of the sky and
suggest clouds.

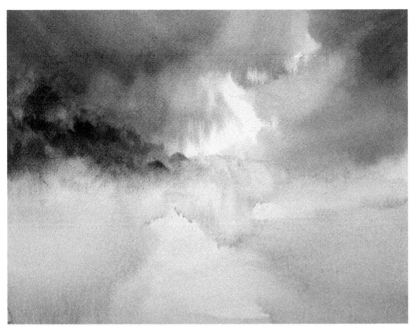

3. Create a stronger sky mix (less water, more paint) and brush in the storm clouds on the left hand side.

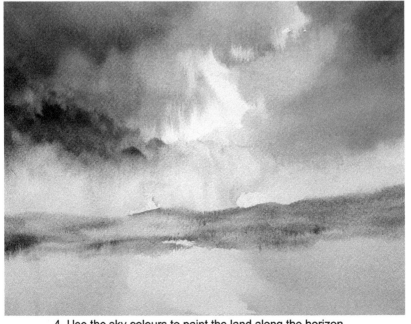

4. Use the sky colours to paint the land along the horizon.

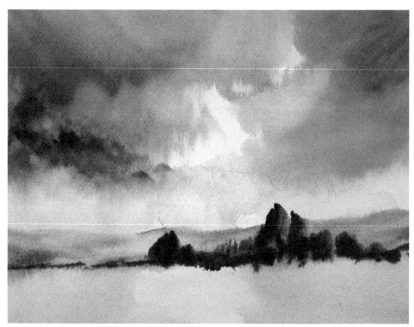

5. Add some trees and bushes using a strong mix of lemon yellow / Payne's gray.

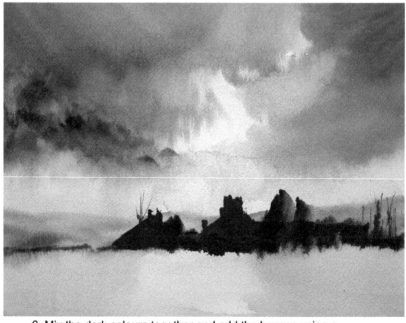

6. Mix the dark colours together and add the houses using a flat brush.

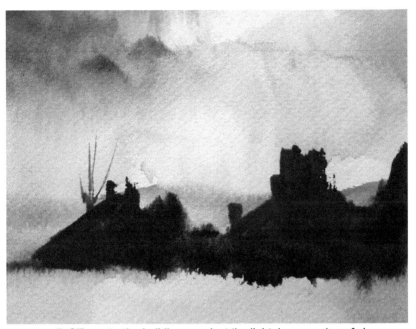

7. Silhouette the buildings against the light, lower region of sky.

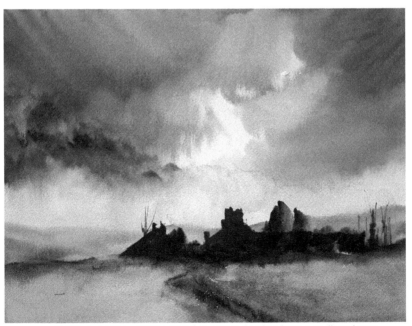

8. Work on the middle and foreground using lemon yellow / raw sienna. Add the path using the hake and light red / ultramarine.

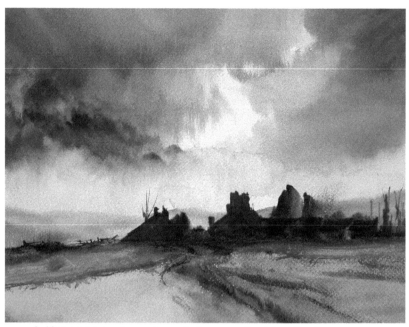

9. Use some neat raw sienna to increase the intensity of colour.

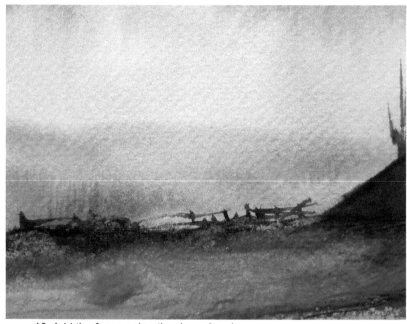

10. Add the fence using the rigger brush.

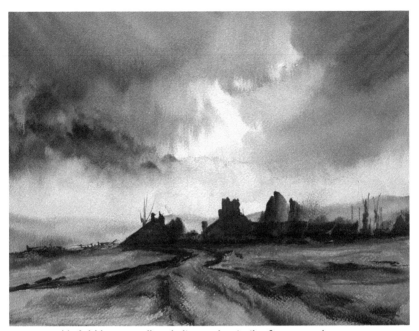

11. Add lemon yellow / ultramarine to the foreground areas
before using the rigger and a dark mix to apply the lines.

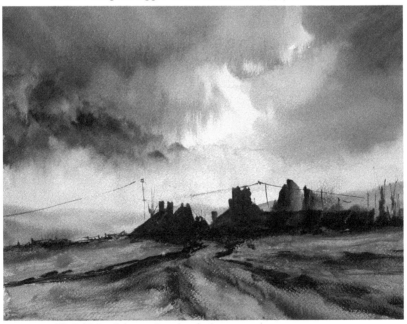

12. Add the telegraph poles / wires.

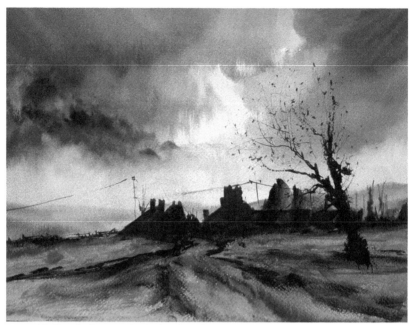

13. Brush the tree in dark using the number 3 rigger.

14. Keep the details loose without fussing.

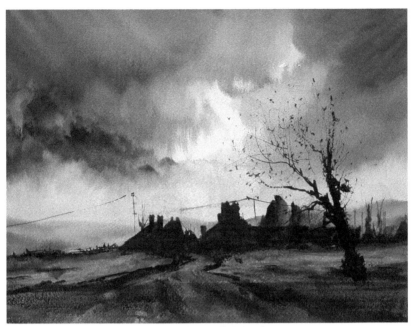

15. Finally sign your painting and sit back.

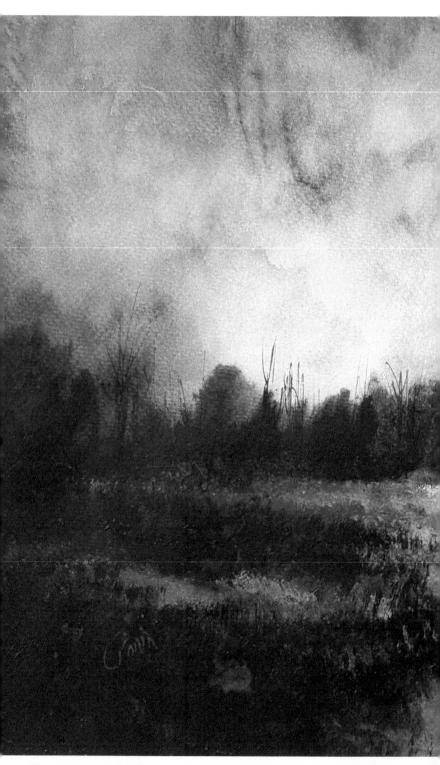

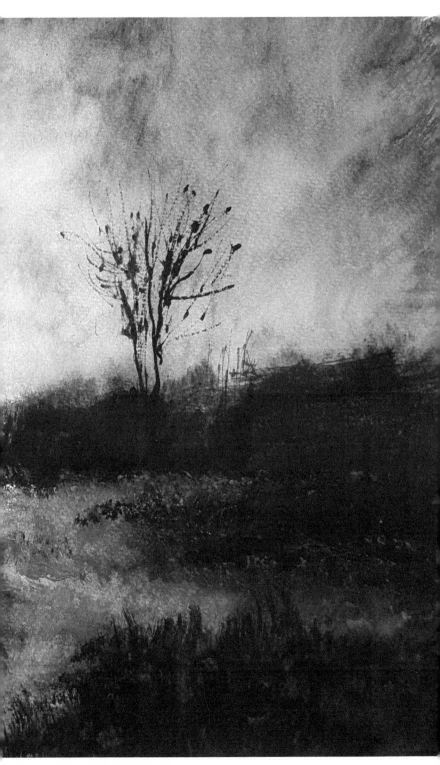

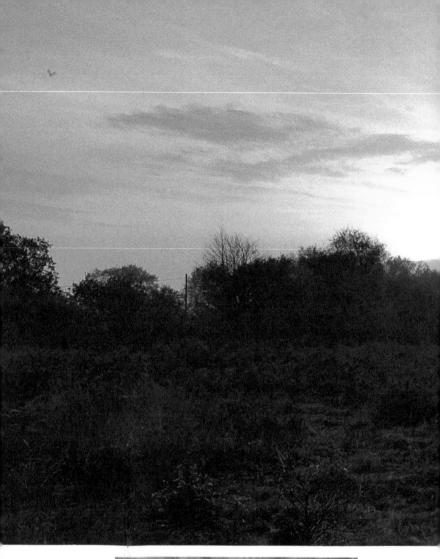

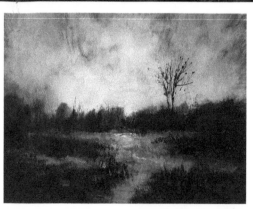

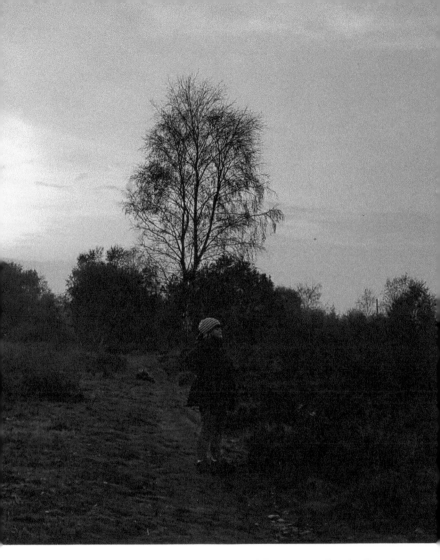

Unusually for me I used a little white gouache in front of the horizon trees to try and add a little sparkle from the setting sun. It took two or three washes to get the desired dark tones (drying in between). I omitted the figure, deciding to allow the closer tree centre stage.

Mousehole is a wonderful little Cornish harbour village renowned for its artists. On my last visit I passed four of them on separate corners on my way down from the car park to the beach, each attempting to capture their own take on this fabulous place.

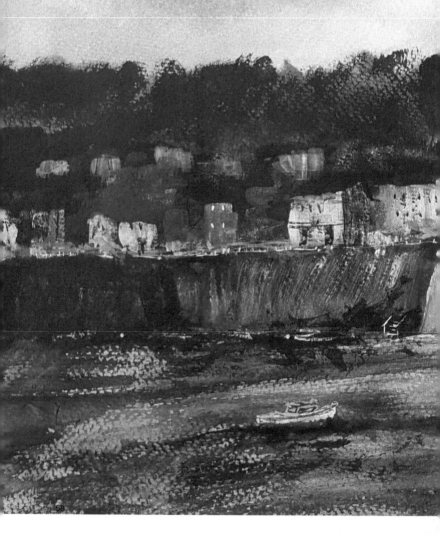

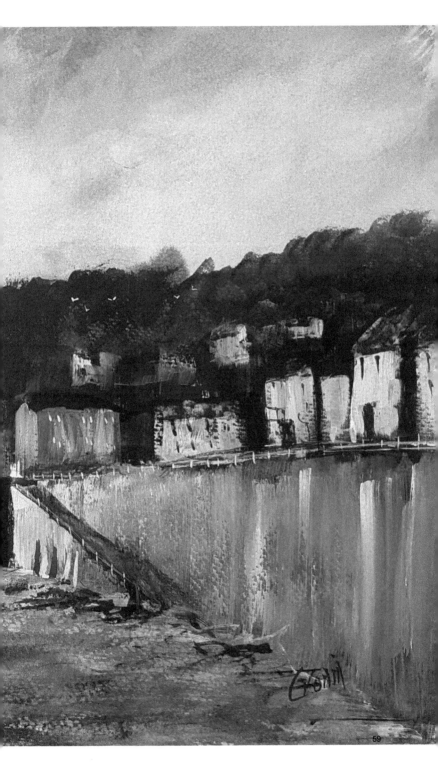

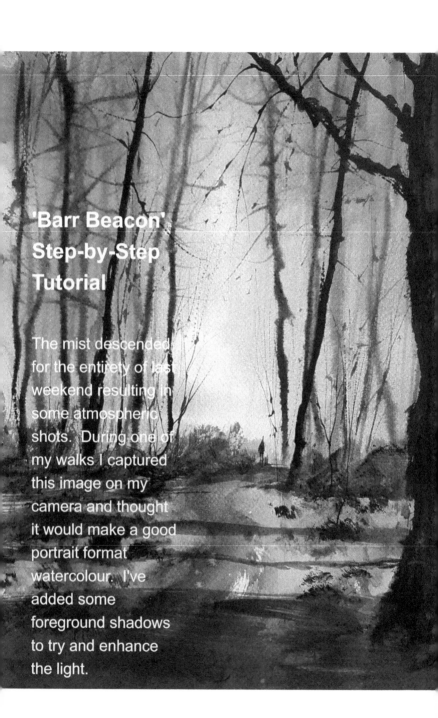

'Barr Beacon' Step-by-Step Tutorial

The mist descended for the entirety of last weekend resulting in some atmospheric shots. During one of my walks I captured this image on my camera and thought it would make a good portrait format watercolour. I've added some foreground shadows to try and enhance the light.

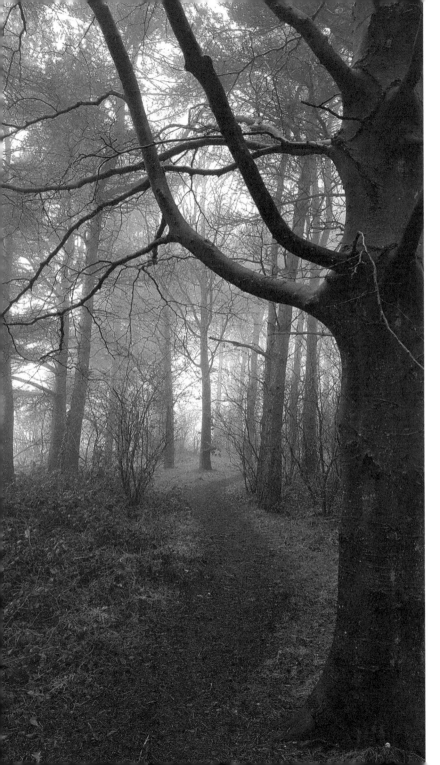

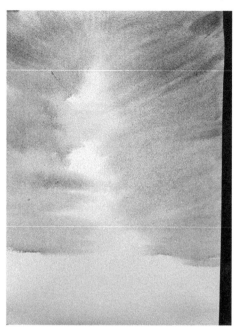

1. Kick it off with some ultramarine but leave a lighter area in the middle for the light.

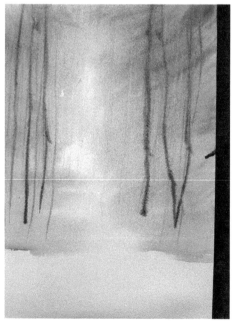

2. Use the rigger to start adding the trees.

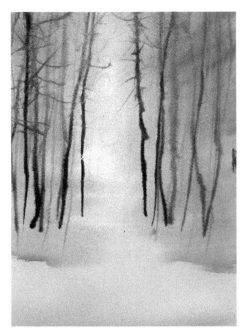

3. As the trees get closer to the foreground make the mix stronger (less water and more paint).

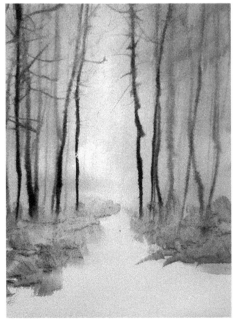

4. Use various mixes of raw sienna / lemon yellow / ultramarine to add the grass.

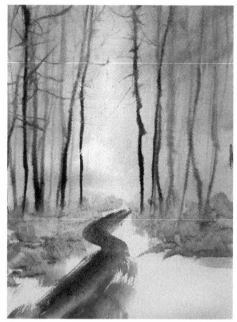

5. Brush in the path using light red / ultramarine with a quick sweep of the hake.

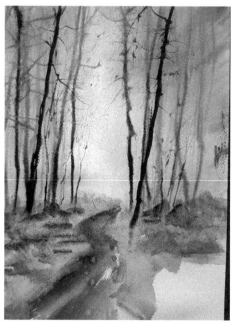

6. Work the grass up to the edge of the path.

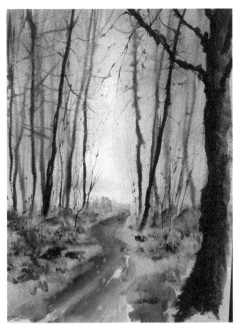

7. Use the hake and burnt umber / ultramarine to add the foreground tree.

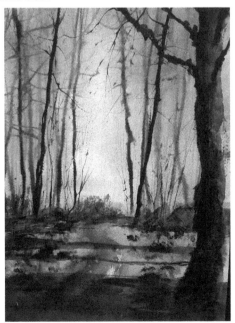

8. Use a weak mix of light red / burnt umber / ultramarine to add the shadows.

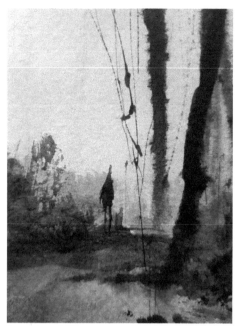

9. Use the rigger to add the man and dog.

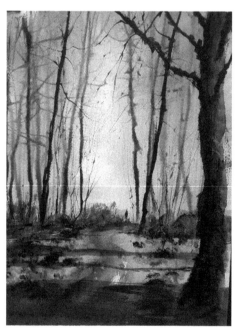

10. Sign your painting and sit back!

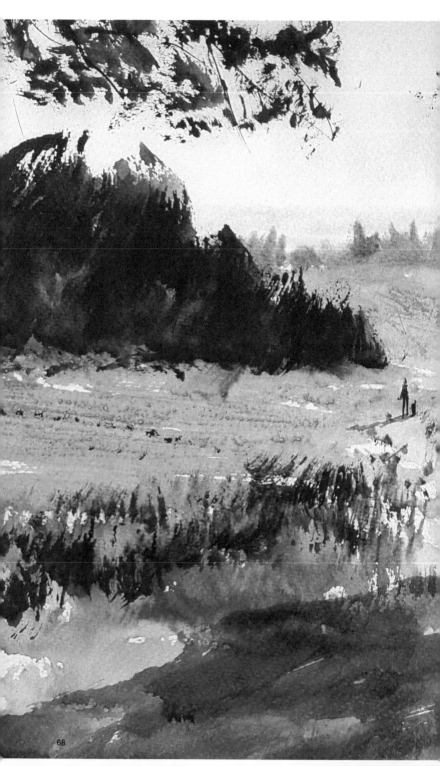

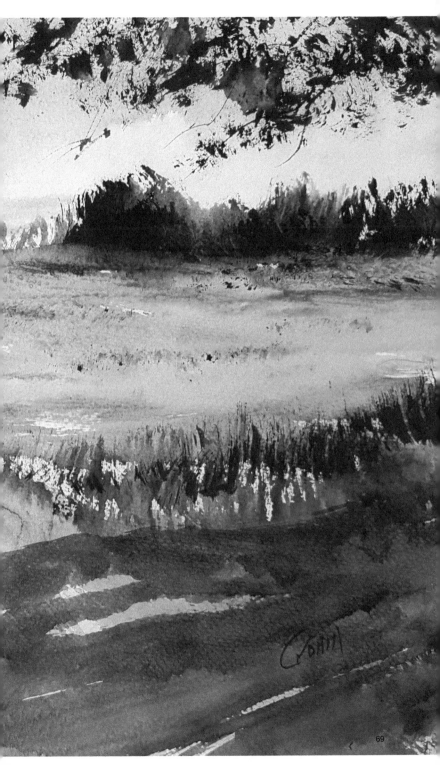

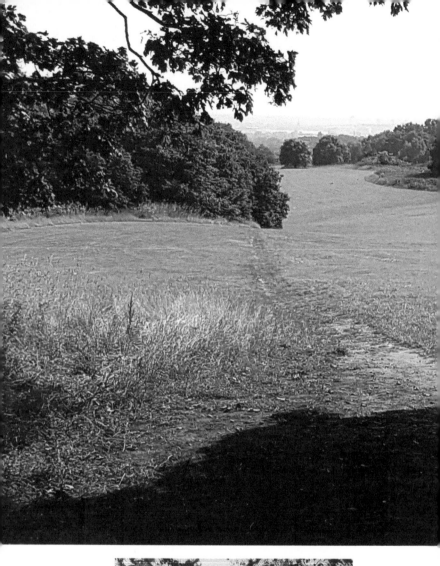

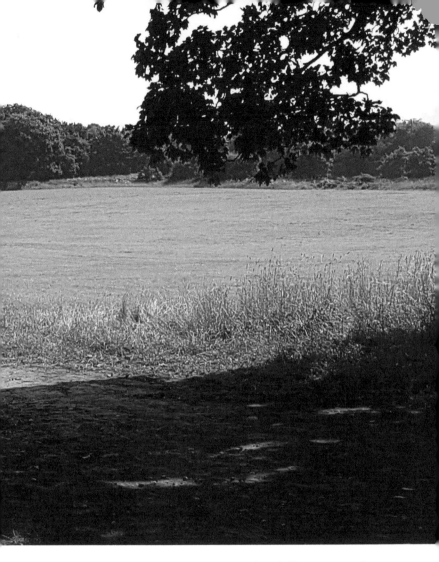

You would never have thought this idyllic, tranquil scene lies just yards from the busy M6 motorway. The intense foreground shadow was what drew me to this view. The watercolour pretty much painted itself after that with little needing changing from the reference.

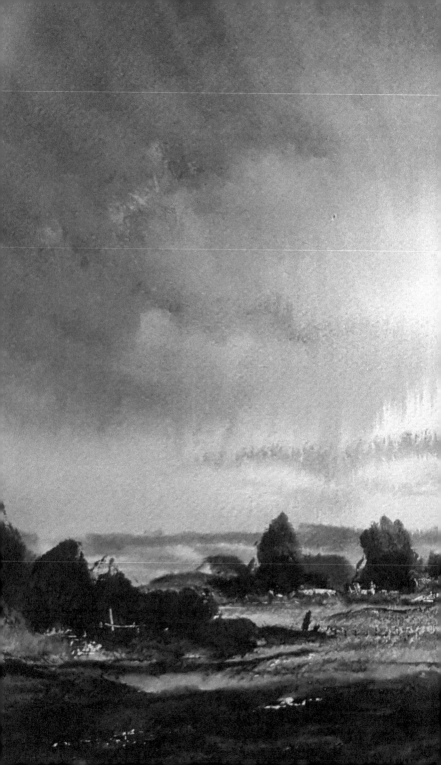

'Evening Light' Step-by-Step Tutorial

I was pleased with the light in this painting. I did the shadows differently this time. Instead of brushing a shadow wash over previously painted ground as I usually do, I painted the foreground dark in tone straight from the off so the shadow effect was there instantly. There were a couple of things however I would have done differently. Firstly, the houses are equally separated which looks rubbish. I should have bunched some together.

Secondly, initially I was going to place a tree in the right foreground but decided against it. Looking at it now, that area looks a little bare and in hindsight I think the scene may have benefited from the tree.

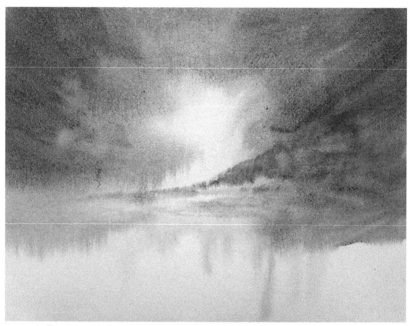

1. There's a little raw sienna in there but the sky is predominantly alizarin crimson / ultramarine.

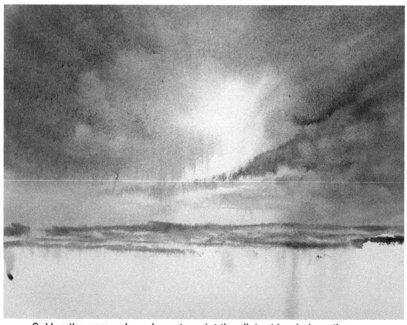

2. Use the same sky colours to paint the distant land along the horizon.

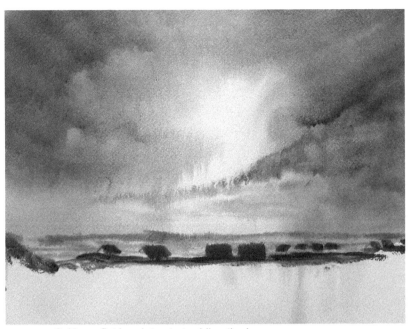

3. Use a flat brush to start adding the houses.

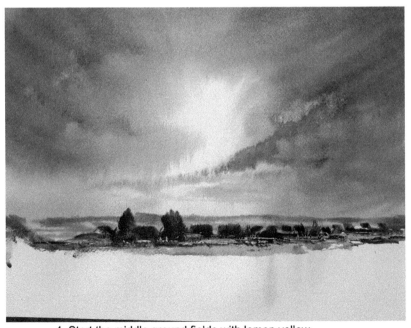

4. Start the middle ground fields with lemon yellow.

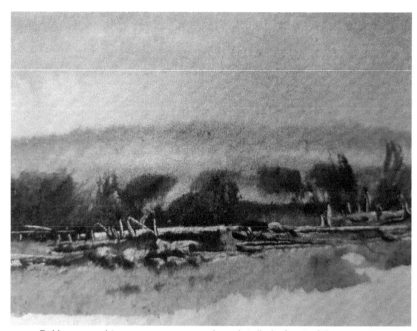

5. Use a card to scrape some random details in front of the houses.

6. Don't worry too much with the scraping. Keep it loose and let the viewer's eye imagine the rest.

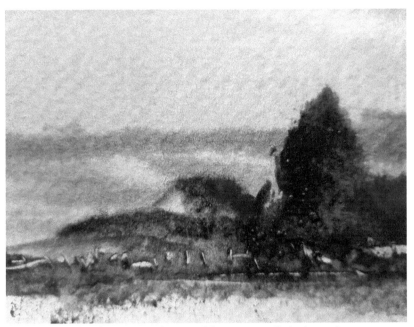

7. A few fence posts here and there generally look good.

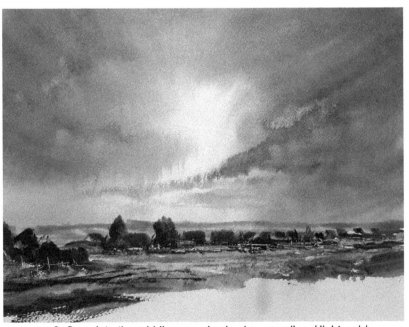

8. Complete the middle ground using lemon yellow / light red / burnt umber.

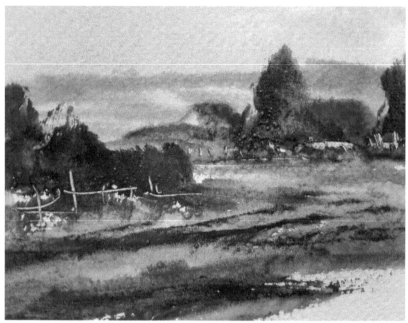

9. Add some darker tones here and there.

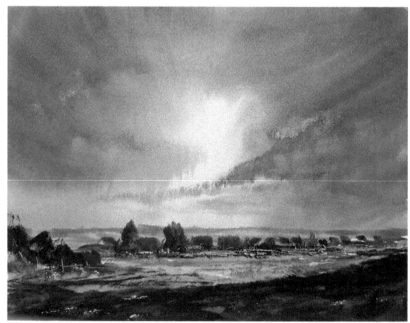

10. Add the foreground with a strong mix of light red / burnt umber / ultramarine.

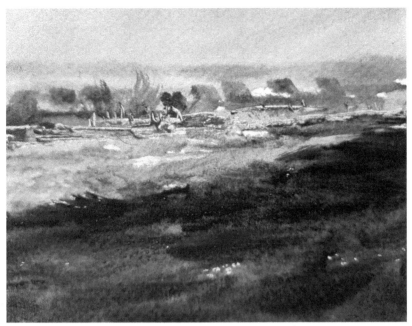

11. Make it dark by allowing the paint to dry before adding another layer on top.

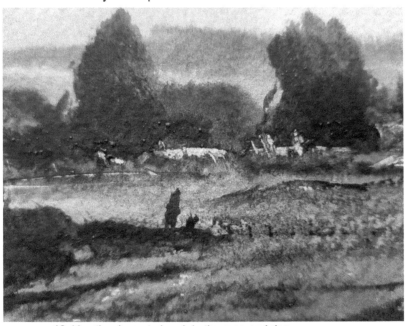

12. Use the rigger to brush in the man and dog.

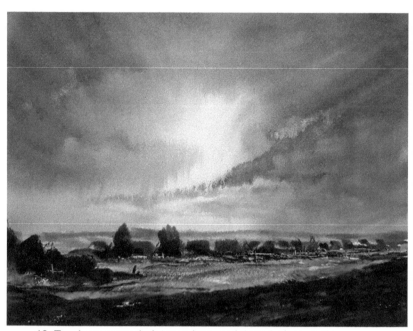

13. Touch up some dark tones here and there before signing your painting.

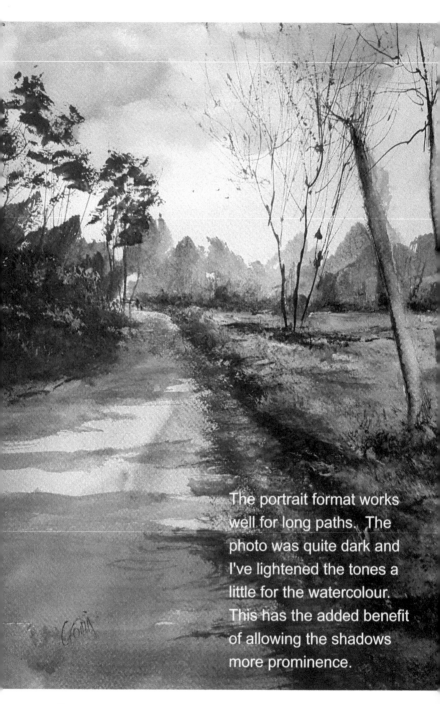

The portrait format works well for long paths. The photo was quite dark and I've lightened the tones a little for the watercolour. This has the added benefit of allowing the shadows more prominence.

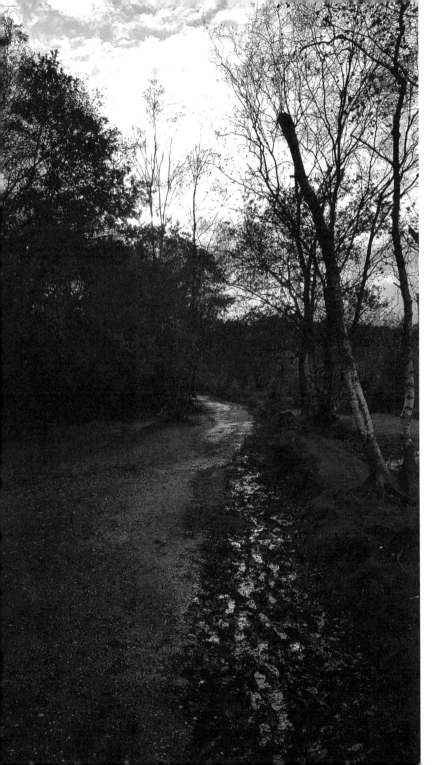

'Near Streetly Gate' Step-by-Step Tutorial

This was our Sunday afternoon stroll through Sutton Park as the snow came down. I moved to the left to get a better composition (see photograph on the next page) but consequently shifted the path further to the right which wasn't ideal. I used just the 3 colours: raw sienna, ultramarine and burn umber.

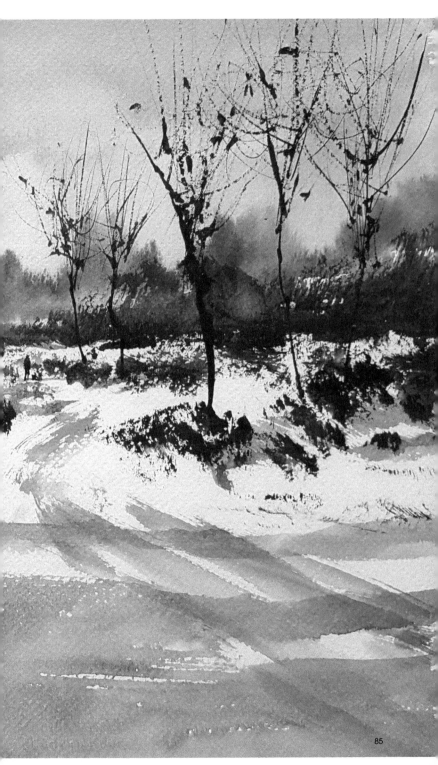

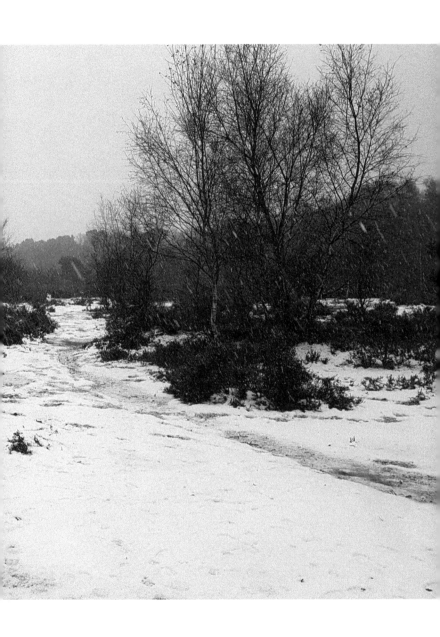

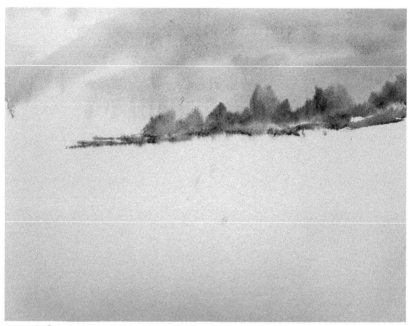

1. Start with a simple sky before using the corner of the hake to add the trees and bushes along the horizon.

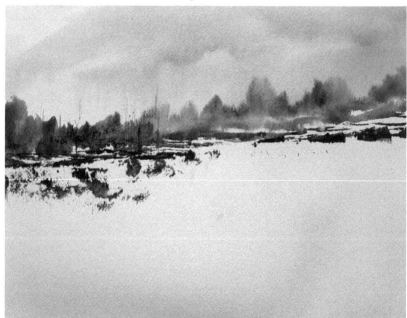

2. Bring the bushes forward on the left hand side. Make dark marks using various combinations of the three colours.

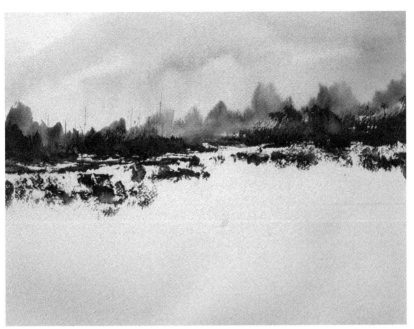

3. Once the paint has dried (or at least halfway there) add the closer bushes using a darker mix.

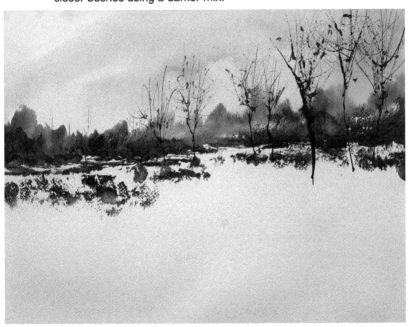

4. Use the 2 rigger brushes to add the trees.

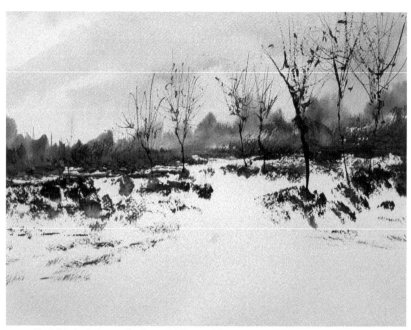

5. Add dark tones in the middle and foregrounds leaving room for the path.

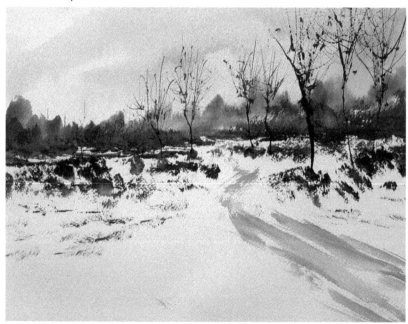

6. Brush in the path with a quick sweep of the hake.

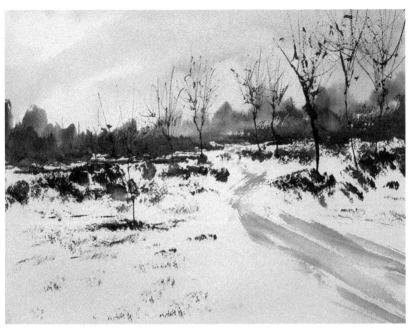

7. Use the corner of the hake to continue the marks through to the foreground.

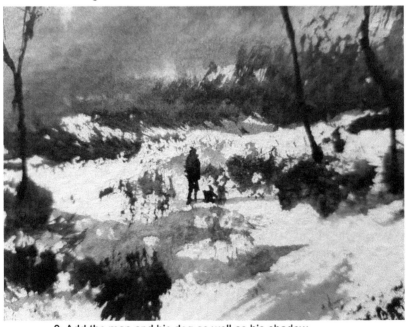

8. Add the man and his dog as well as his shadow.

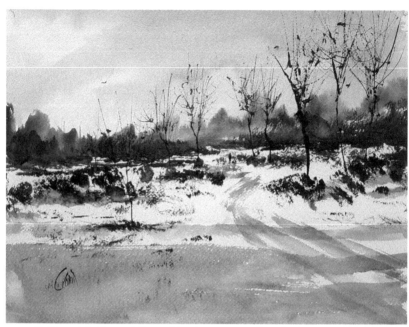

9. Complete the painting with a large sweeping shadow across the foreground. Sign and relax!

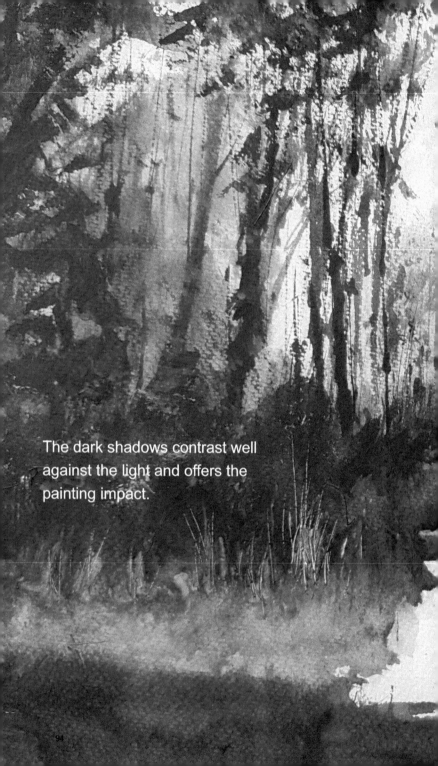

The dark shadows contrast well against the light and offers the painting impact.

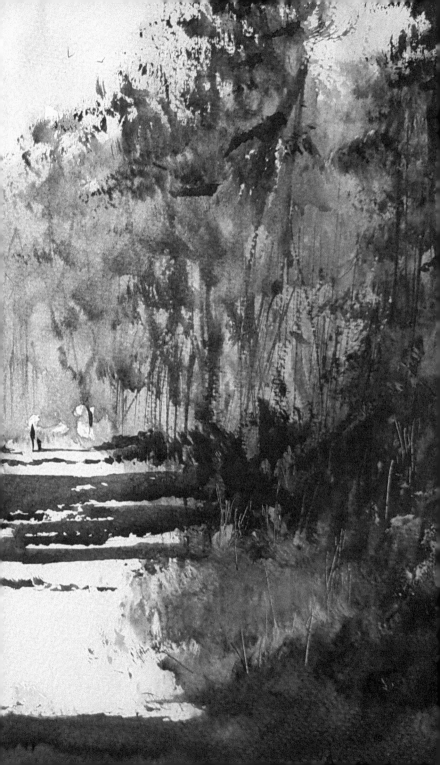

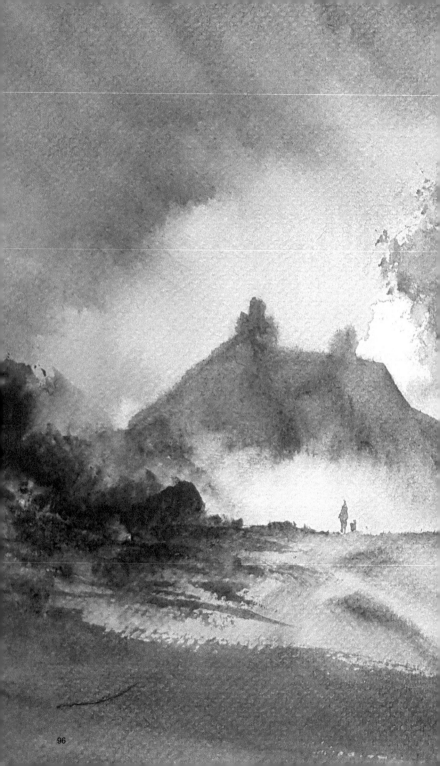

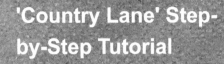

'Country Lane' Step-by-Step Tutorial

This painting depicts an early morning stroll along a deserted country lane. There's a little mist and shadow to help improve the atmosphere.

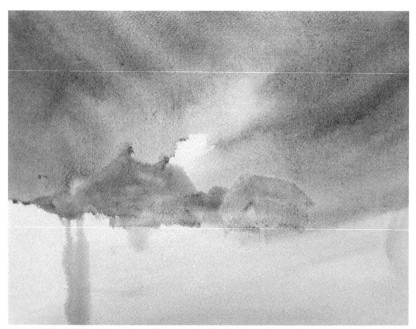

1. Paint the sky using ultramarine / alizarin crimson before using a flat brush and the same colours to add the houses.

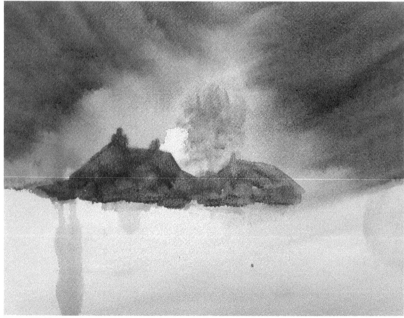

2. If your tones were a little weak (as per mine) then reapply the strokes with a stronger mix before adding the tree.

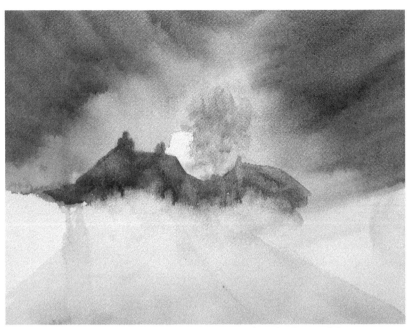

3. Use a clean, damp hake brush to soften the base of the houses creating a misty effect.

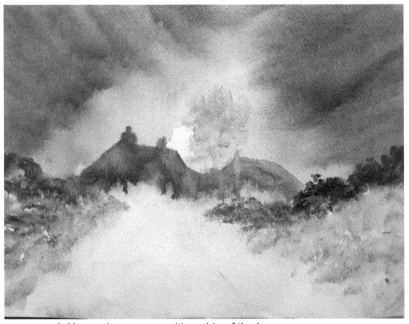

4. Use various greens either side of the lane.

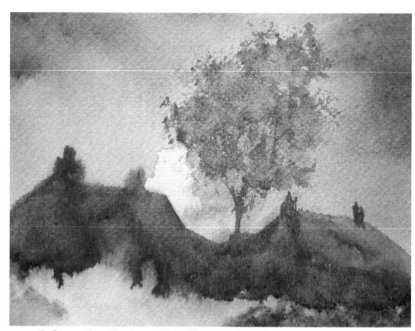

5. Strengthen the tree a little if it needs it. Mine was looking a bit weak.

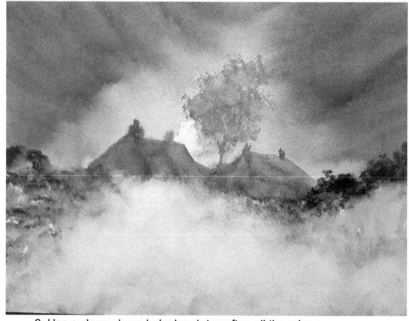

6. Use a clean, damp hake brush to soften all the edges.

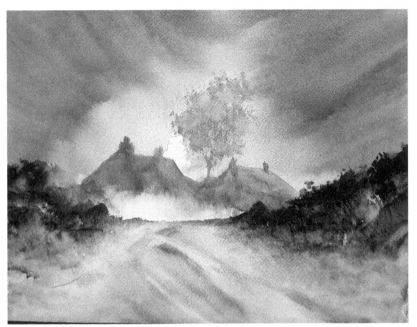

7. Continue adding the greens either side of the lane to define the road more clearly.

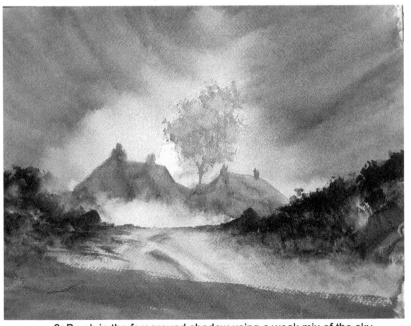

8. Brush in the foreground shadow using a weak mix of the sky colours.

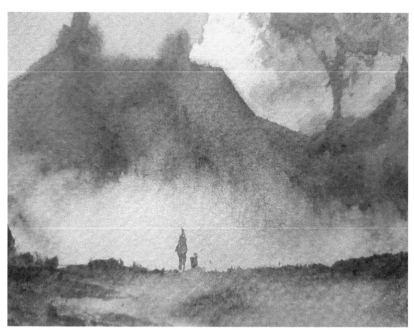

9. Add the man and dog using a rigger brush.

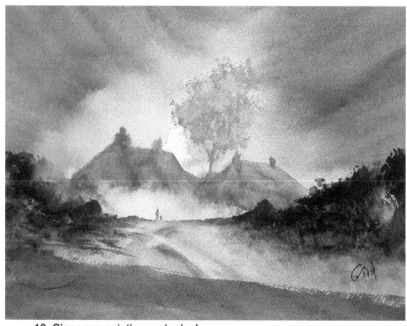

10. Sign your painting and relax!

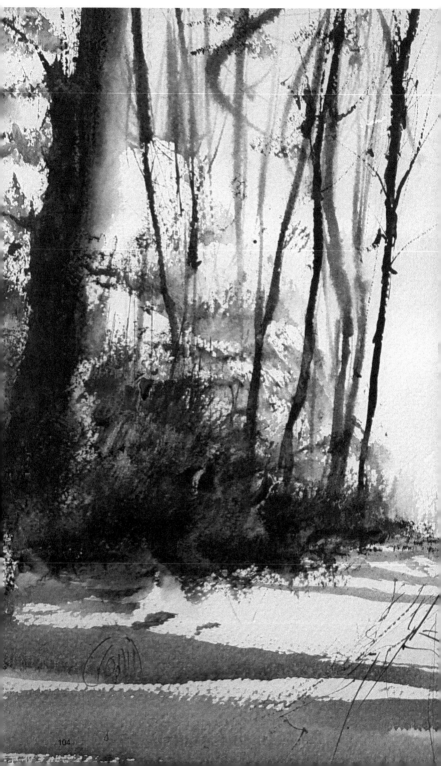

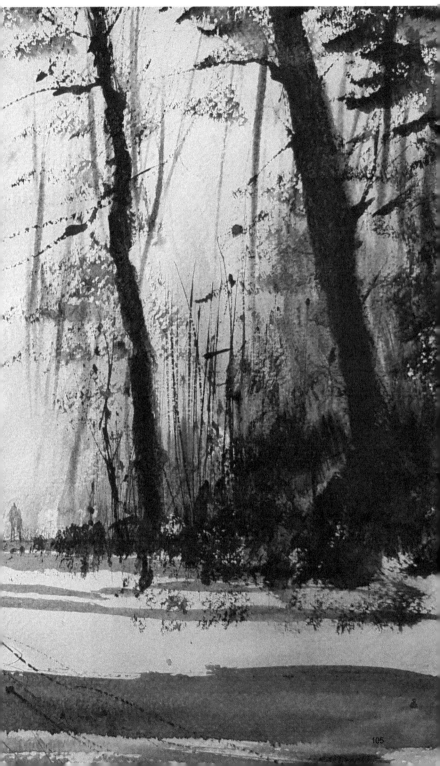

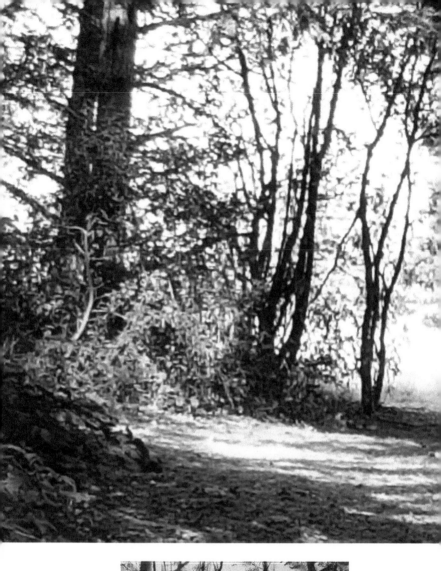

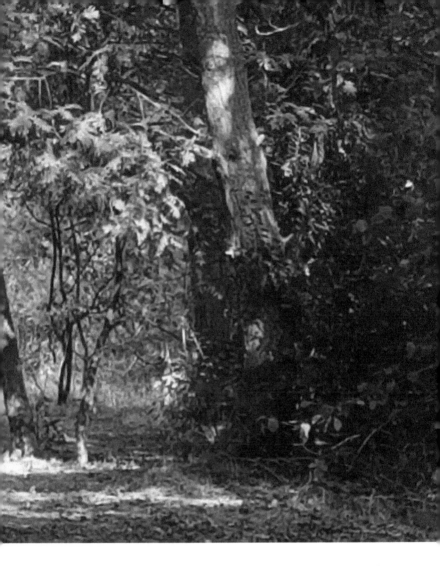

Here I've used a photograph of Barr Beacon I took in the summer and adapted it for a winter scene. I used just the 3 colours: raw sienna, burnt umber and ultramarine. I consider these colours as my winter palette.

'Village by the Sea' Step-by-Step Tutorial

I've used a limited palette for this simple composition of an idyllic village life by the sea. I've lived inland all my life and dream one day of living in such a place. I used a small flat brush for most of the detail. The village area is painted in a darker tone to contrast against the rest of the watercolour.

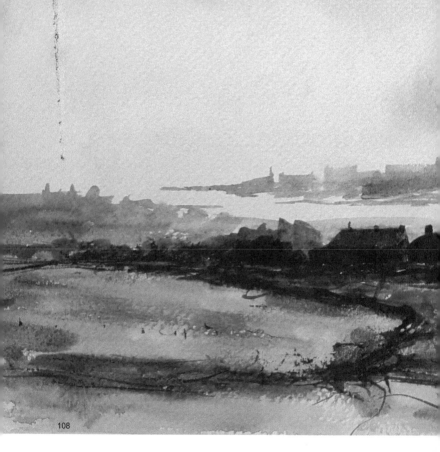

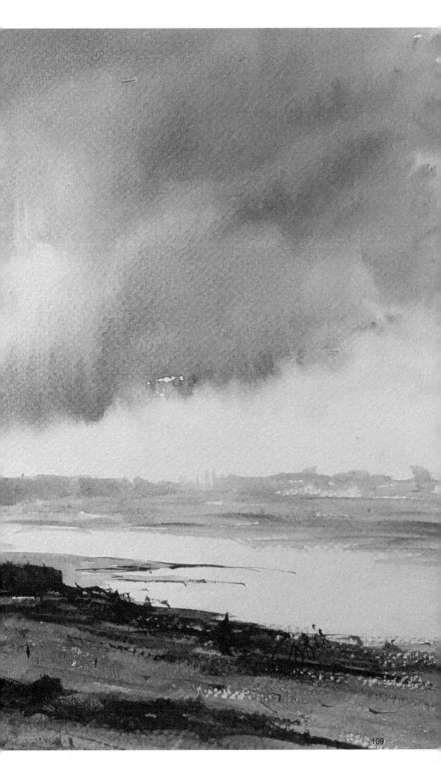

1. Begin with raw sienna before brushing an ultramarine / alizarin crimson mix into the sky.

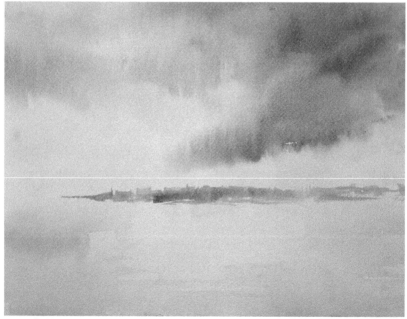

2. Use the sky colours and a small flat brush to add the horizon details.

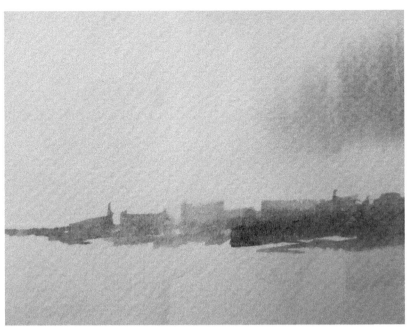

3. Just focus on blocking in the buildings without any detail.
Keep it loose and simple.

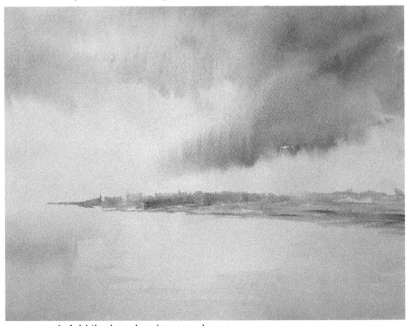

4. Add the beach using raw sienna.

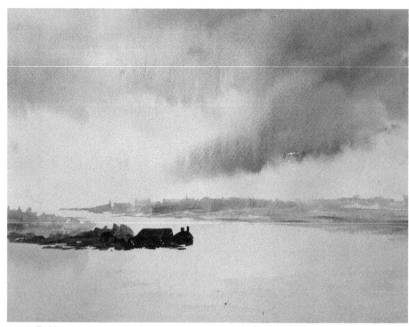

5. Use a strong mix (less water, more paint) of sky colours and the small flat to brush in the village.

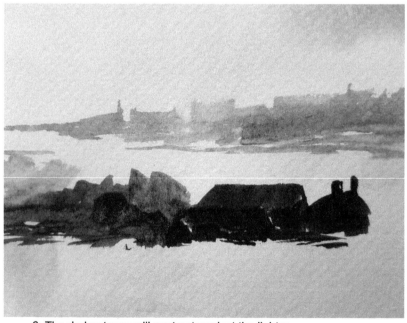

6. The darker tones will contrast against the lighter background.

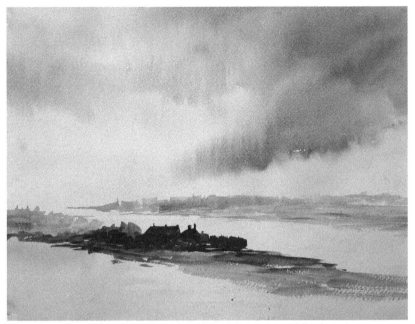

7. Use a generous amount of raw sienna to add the beach.

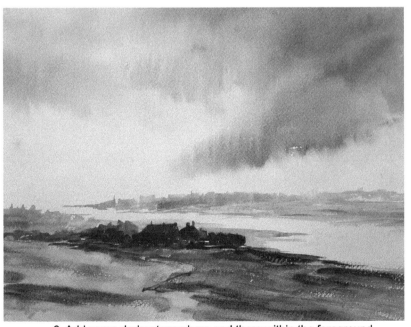

8. Add some darker tones here and there within the foreground beach region.

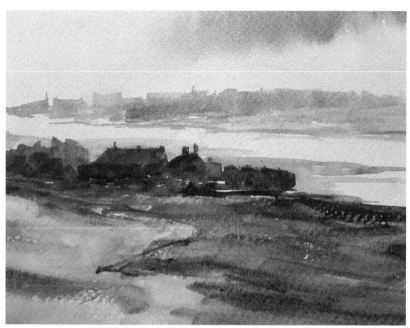

9. Use the rigger and add random lines for interest.

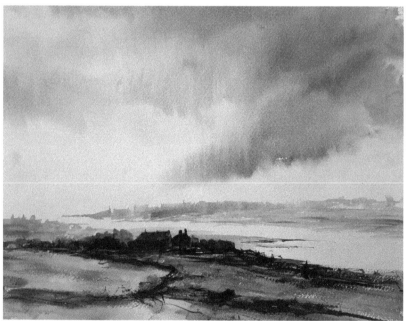

10. View your painting from a distance to get a better idea of
the tonal contrast. Add the darks here and there as necessary.

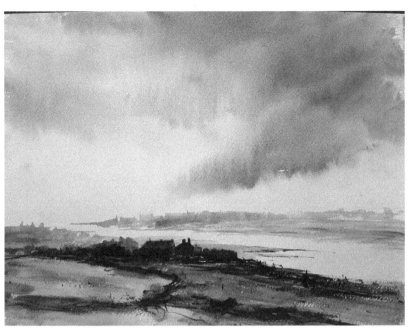

11. Add fence posts and some random details with the rigger before signing your painting.

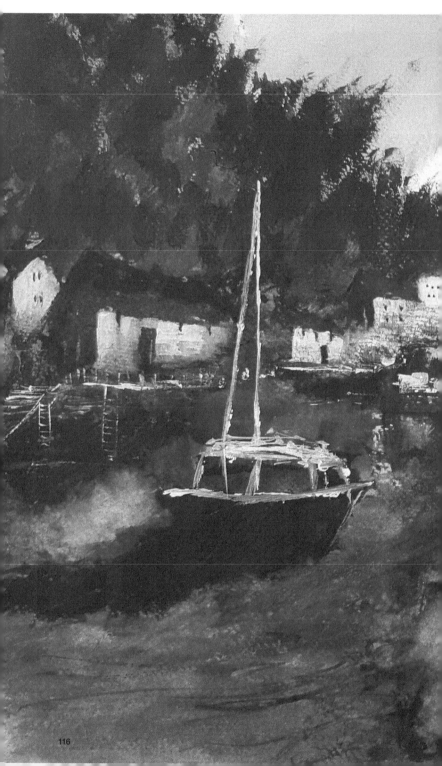

I was experimenting with white acrylic in this harbour scene. It's something I have little to no experience with but worth investigating for future paintings I think.

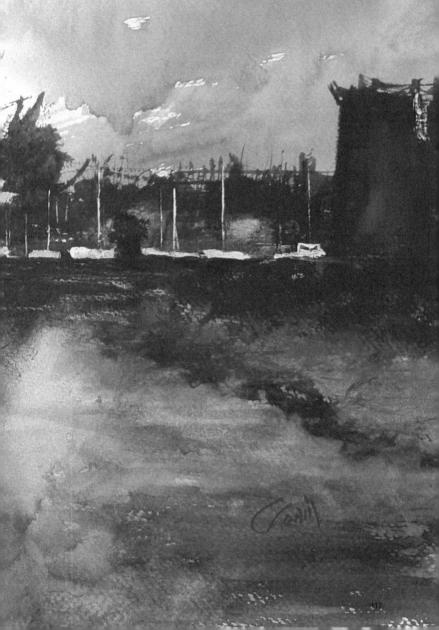

'Windmill' Step-by-Step Tutorial

Distinctive objects like windmills make a great focal point for paintings. Here I've blocked it in dark to silhouette against the sky.

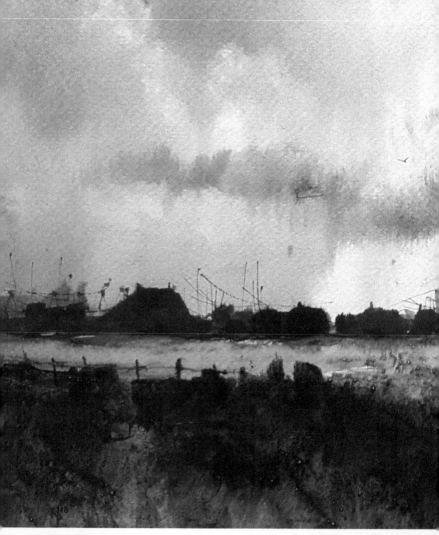

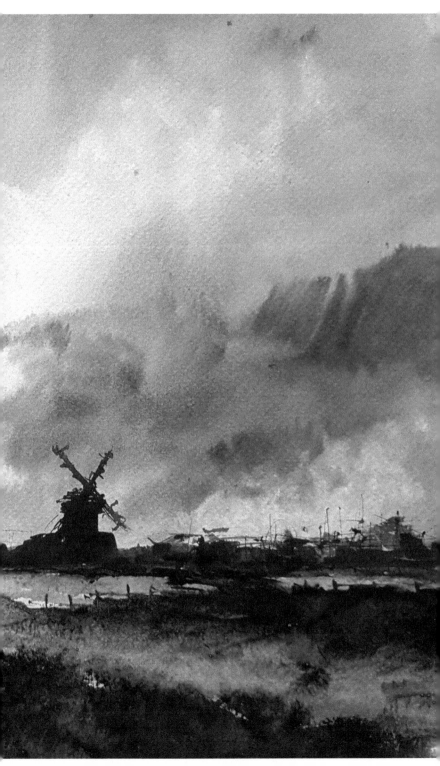

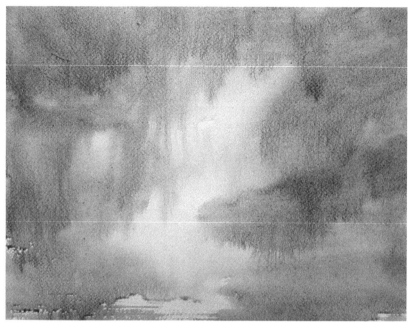

1. The initial wash is various mixes of raw sienna / alizarin crimson / ultramarine.

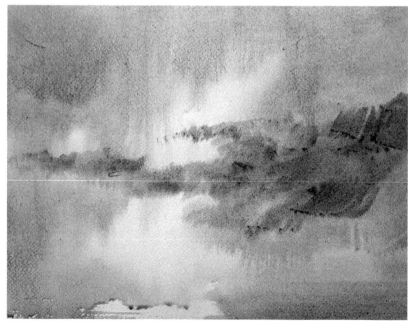

2. Add the clouds using alizarin crimson / Payne's gray.

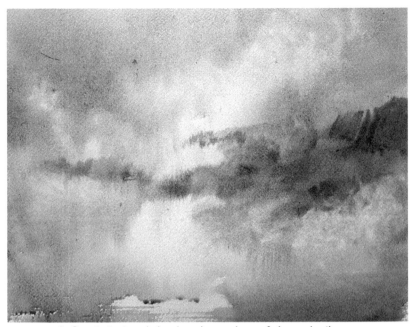

3. Create textured clouds using a piece of clean, dry tissue.

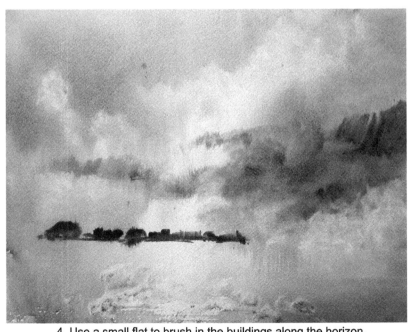

4. Use a small flat to brush in the buildings along the horizon.

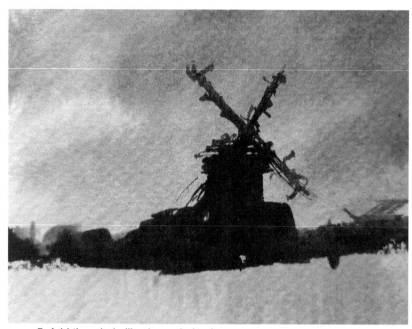

5. Add the windmill using a dark mix.

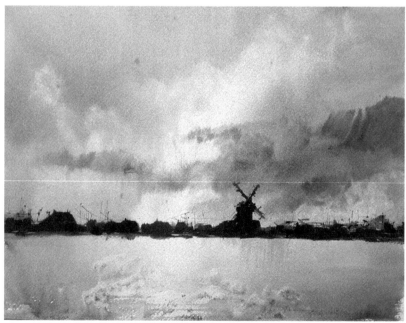

6. Complete the horizon line using the flat brush.

7. Add some random marks using the rigger. I've probably gone a little overboard here to be honest.

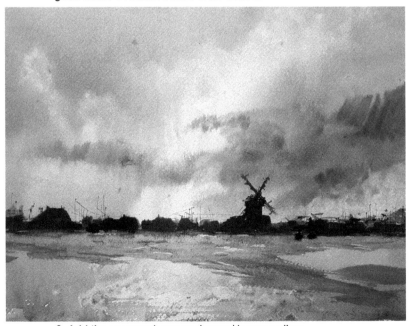

8. Add the grass using raw sienna / lemon yellow.

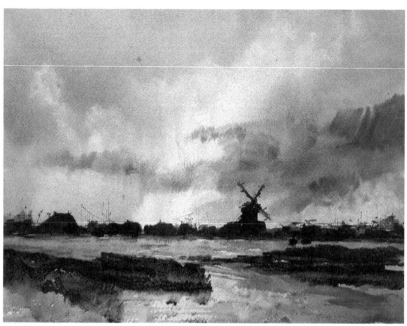

9. Add some darker touches that will help enhance the light.

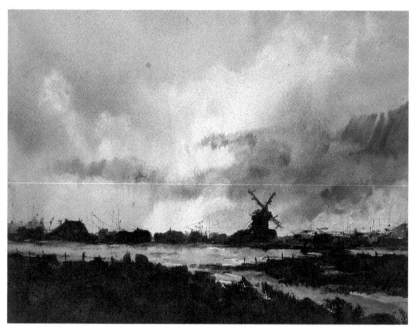

10. Complete the darks into the foreground before adding the
fence posts.

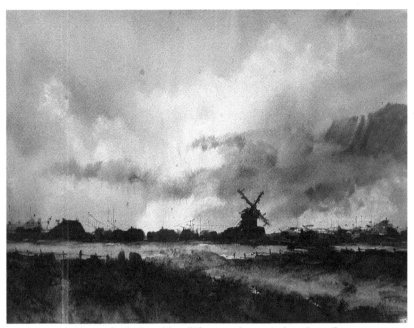

11. Use a dry hake with a little raw sienna to break up the darks a little. Finally sign your painting and relax.

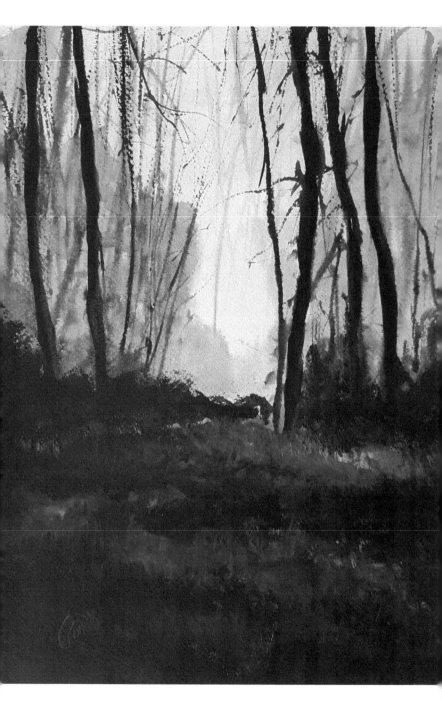

Credits

I am forever indebted to my patrons over at patreon.com/
StevenCronin for their support and encouragement, especially
those at the 'Book Credits' tier and above. At time of writing their
names are:

Gary Bomphray

Sissel Varhaugvik

Michael Miller

Todd Liggitt

ARTree Watercolors

Clara Thore

Dusty Tyukody

Gary Jones

Hanne Bjerregaard

Helena Sweeney

Minty Fownes

Sean Manion

Your support is very much appreciated. I hope you all like the
book and wish each and every one of you the very best of luck
with your watercolours.

Lightning Source UK Ltd.
Milton Keynes UK
UKHW020208290322
400729UK00006B/111